DesignOriginals

Creative Coloring
Birds

Valentina Harper

DESIGN ORIGINALS
an Imprint of Fox Chapel Publishing
www.d-originals.com

Basic Color Ideas

In order to truly enjoy this coloring book, you must remember that there is no wrong way—or right way—to paint or use color. My drawings are created precisely so that you can enjoy the process no matter what method you choose to use to color them!

The most important thing to keep in mind is that each illustration was made to be enjoyed as you are coloring, to give you a period of relaxation and fun at the same time. Each picture is filled with details and forms that you can choose to color in many different ways. I value each person's individual creative process, so I want you to play and have fun with all of your favorite color combinations.

As you color, you can look at each illustration as a whole, or you can color each part as a separate piece that, when brought together, makes the image complete. That is why it is up to you to choose your own process, take your time, and, above all, enjoy your own way of doing things.

To the right are a few examples of ways that you can color each drawing.

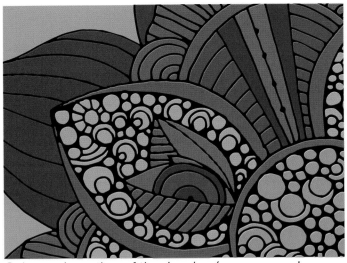

Color each section of the drawing (every general area, not every tiny shape) in one single color.

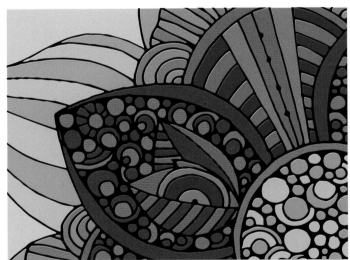

Within each section, color each detail (small shape) in alternating colors.

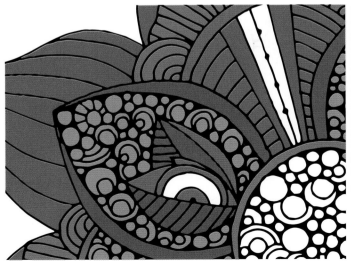

Leave some areas white to add a sense of space and lightness to the illustration.

Basic Color Tips

As an artist, I love to mix techniques, colors, and different mediums when it comes time to add color to my works of art. And when it comes to colors, the brighter the better! I feel that with color, illustrations take on a life of their own.

Remember: when it comes to painting and coloring, there are no rules. The most fun part is to play with color, relax, and enjoy the process and the beautiful finished result.

Feel free to mix and match colors and tones. Work your way from primary colors to secondary colors to tertiary colors, combining different tones to create all kinds of different effects. If you aren't familiar with color theory, below is a quick, easy guide to the basic colors and combinations you will be able to create.

Primary colors: These are the colors that cannot be obtained by mixing any other colors; they are yellow, blue, and red.

Secondary colors: These colors are obtained by mixing two primary colors in equal parts; they are green, purple, and orange.

Tertiary colors: These colors are obtained by mixing one primary color and one secondary color.

Don't be afraid of mixing colors and creating your own palettes. Play with colors—the possibilities are endless!

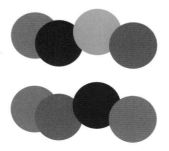
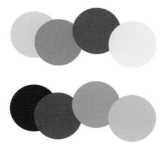

Color Inspiration

On the following eight pages, you'll see fully colored samples of my illustrations in this book, as interpreted by one talented artist and author, Marie Browning. I was delighted to invite Marie to color my work, and she used many different mediums to do so, all listed below each image. Take a look at how Marie decided to color the doodles, and find some inspiration for your own coloring! After the colored samples, the thirty delightful drawings just waiting for your color begin. Remember the tips I showed you earlier, think of the color inspiration you've seen, and choose your favorite medium to get started, whether it's pencil, marker, watercolor, or something else. Your time to color begins now, and only ends when you run out of pages! Have fun!

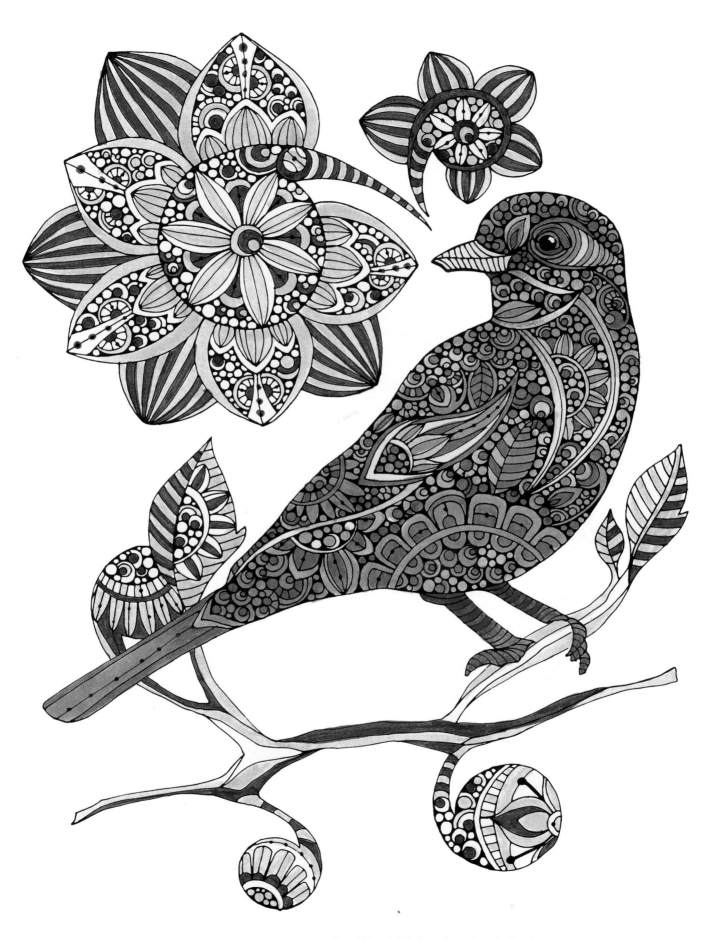

Dual Brush Markers (Tombow). Cool tones. Color by Marie Browning.

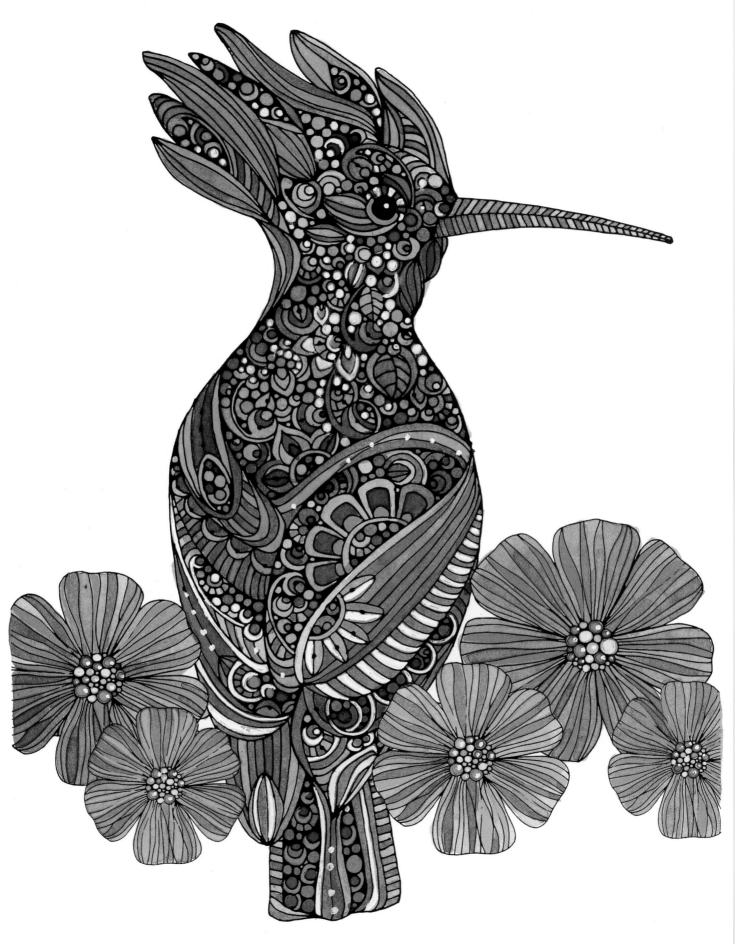

Watercolors (Winsor & Newton), Gel Pens (Sakura).
Bright tones. Color by Marie Browning.

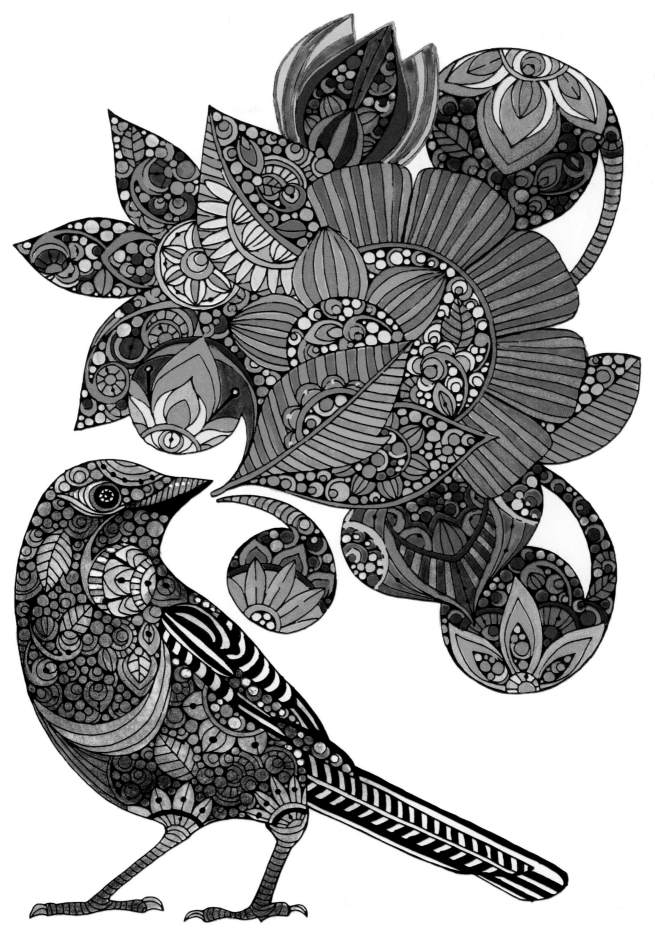

Dual Brush Markers (Tombow), Irojiten Colored Pencils (Tombow).
Bright tones. Color by Marie Browning.

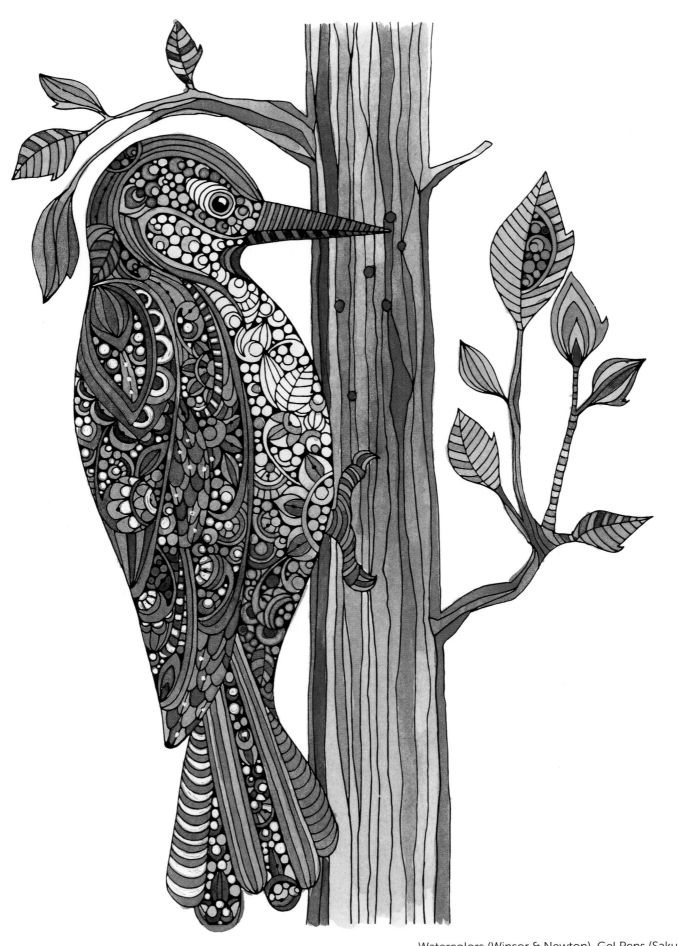

Watercolors (Winsor & Newton), Gel Pens (Sakura).
Natural tones. Color by Marie Browning.

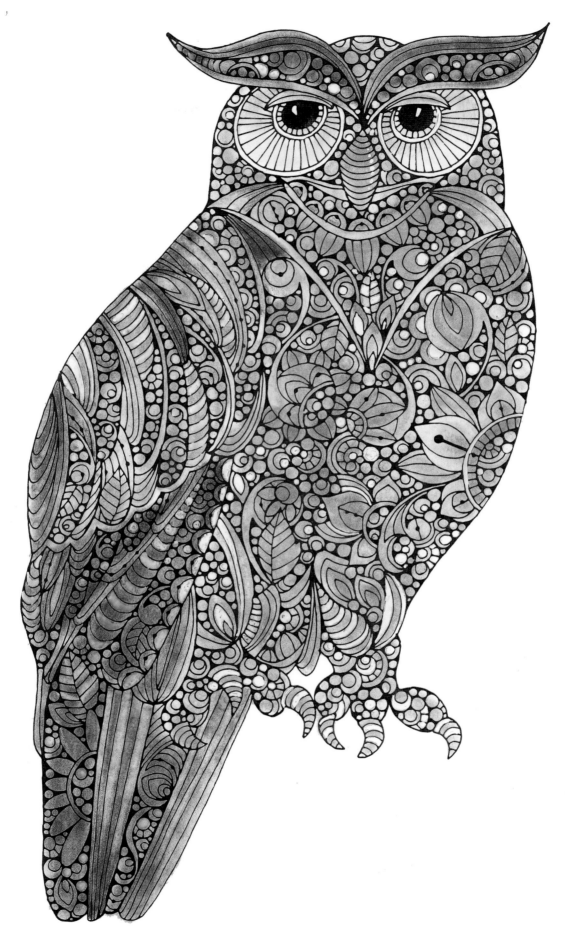

Pitt Pastel Pencils (Faber-Castell), Gel Pens (Sakura).
Soft bright tones. Color by Marie Browning.

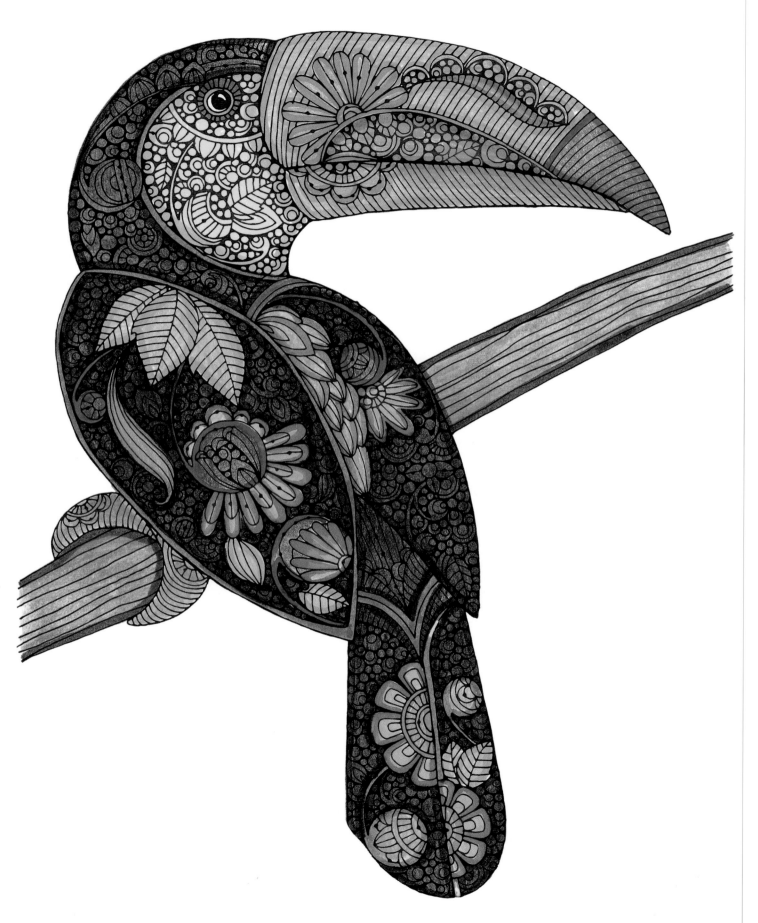

© Valentina Harper, www.valentinadesign.com

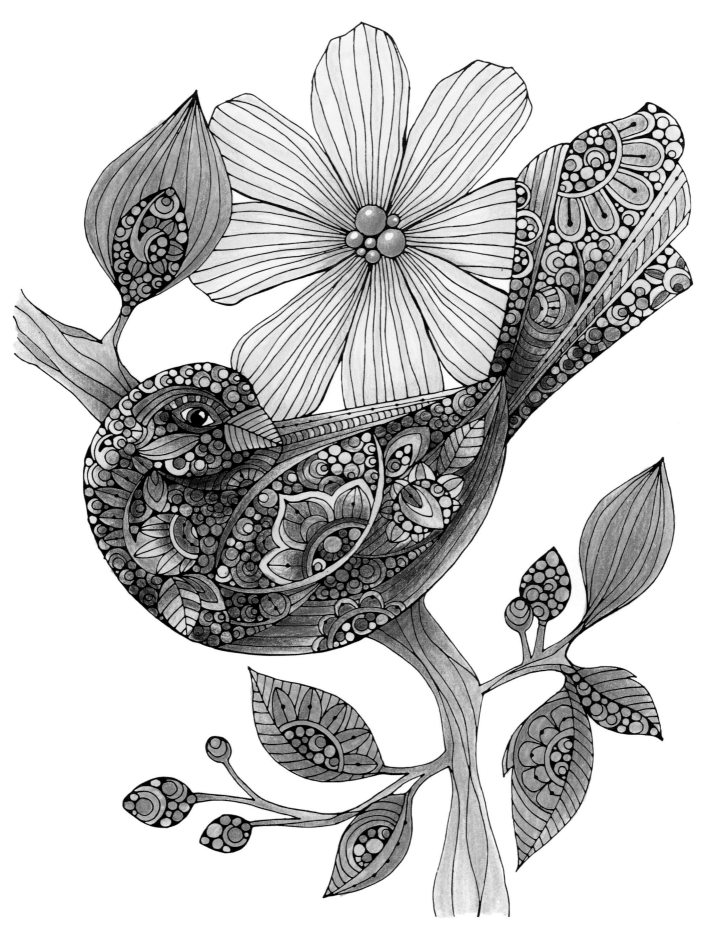

Dual Brush Markers (Tombow), Irojiten Colored Pencils (Tombow).
Vivid tones. Color by Marie Browning.

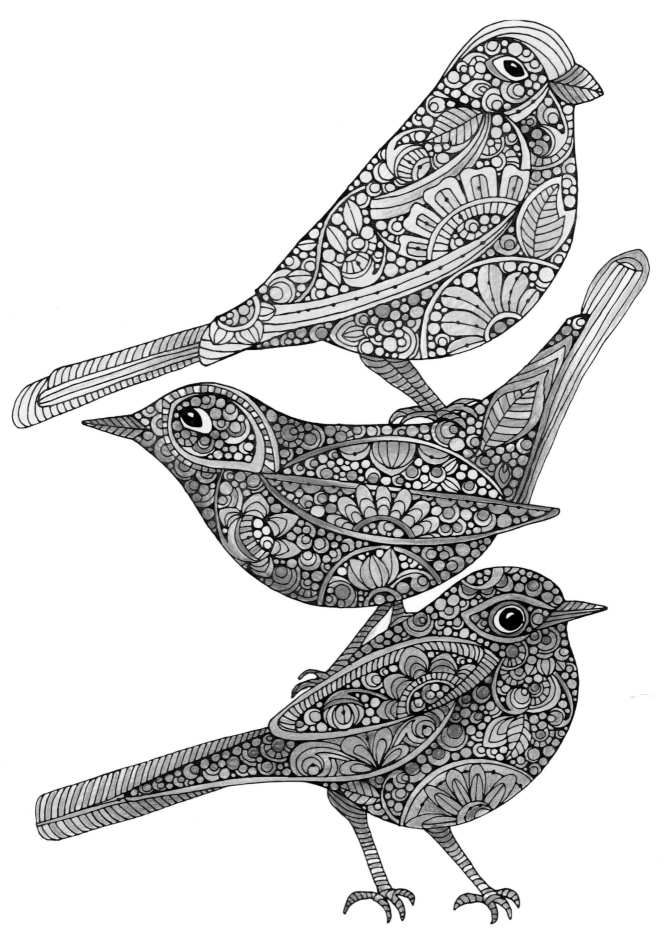

Irojiten Colored Pencils (Tombow). Analogous
warm tones. Color by Marie Browning.

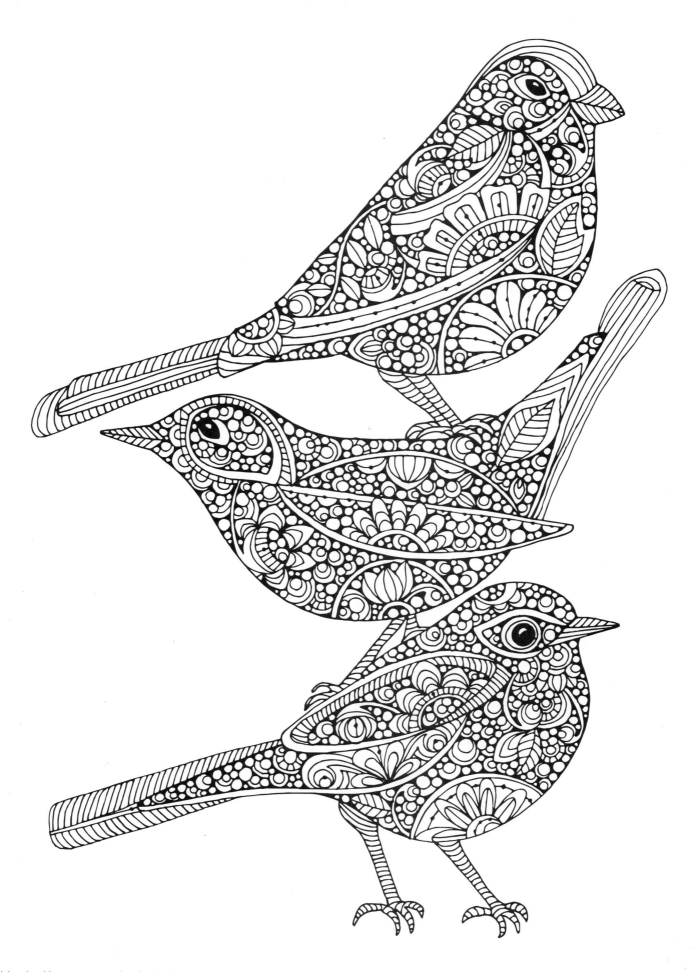

Birds of a feather flock together.

—William Turner

Emma, Mickey, and Mary

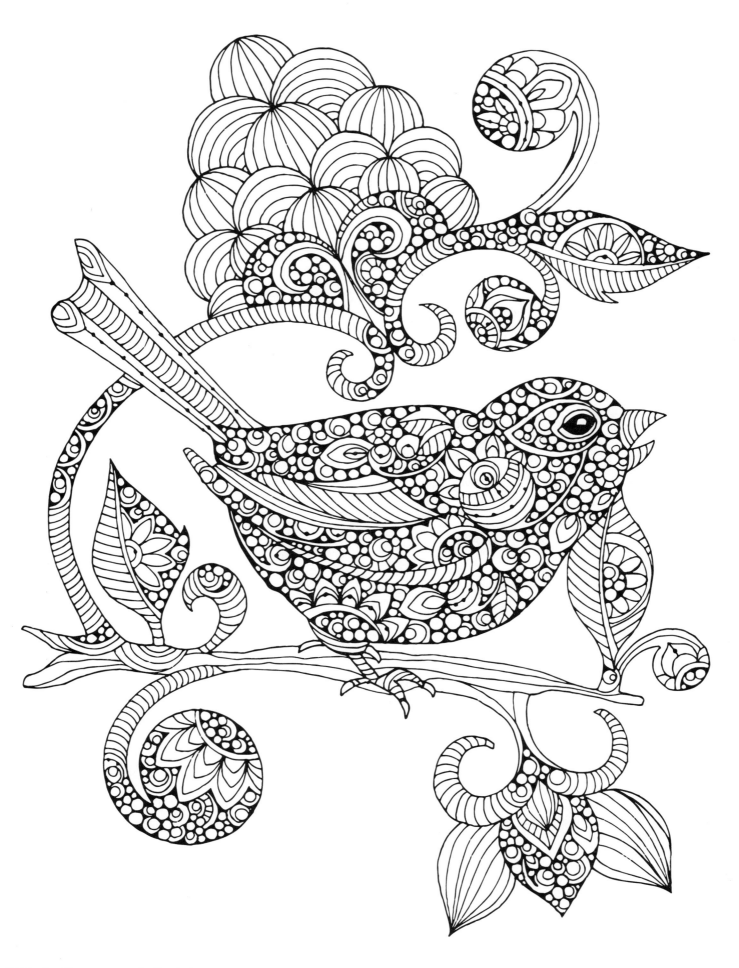

Be like the bird, who
Halting in his flight
On limb too slight,
Feels it give way beneath him,
Yet sings,
Knowing he hath wings.

—**Victor Hugo**, *The Bird*

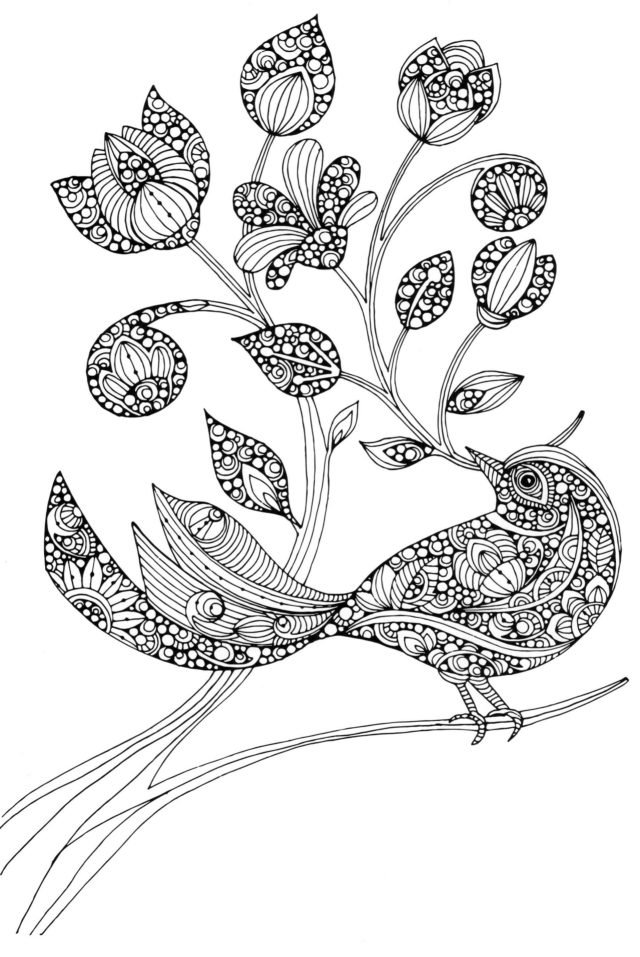

Hope is the thing with feathers
That perches in the soul
And sings the tune without the words
And never stops at all.

—Emily Dickinson, *Hope is the thing with feathers*

Babette

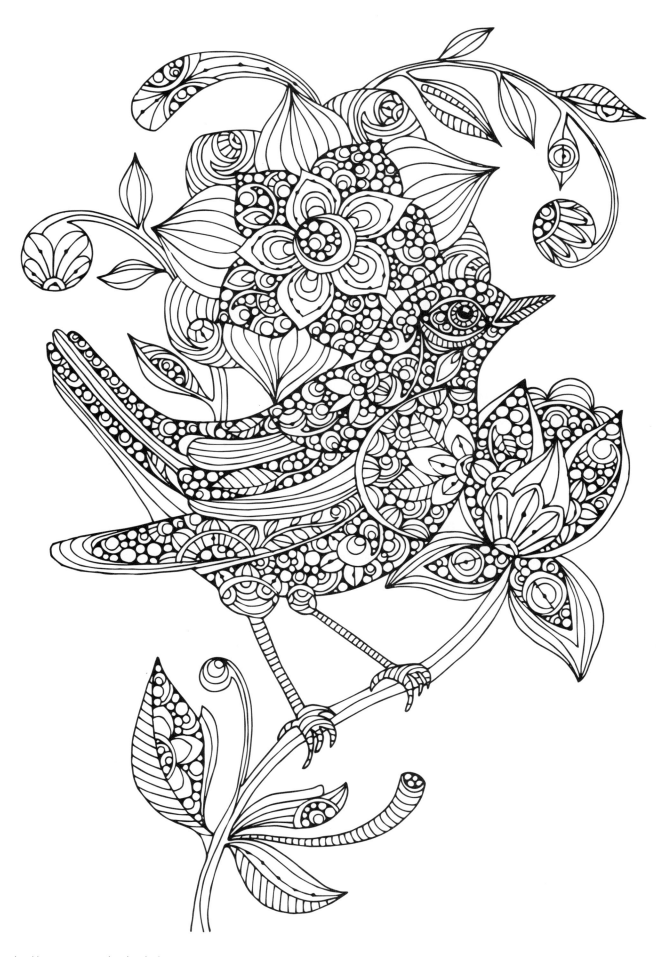

Don't be afraid to give up the good to
go for the great.

—John D. Rockefeller

Cindy

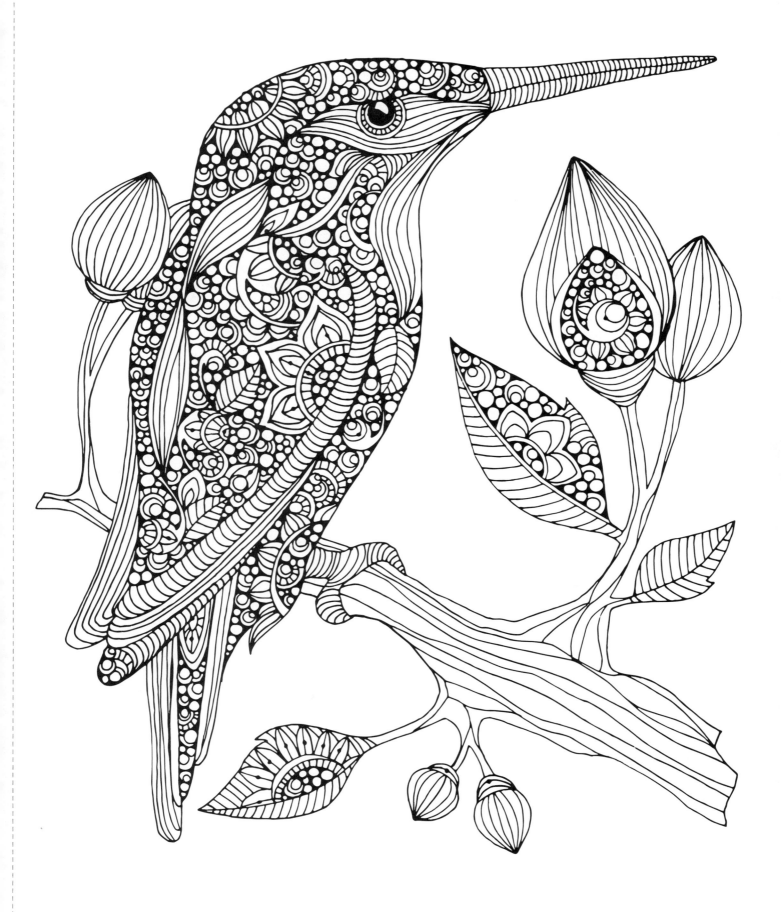

Sometimes you just have to take the leap and build your wings on the way down.

—Kobi Yamada

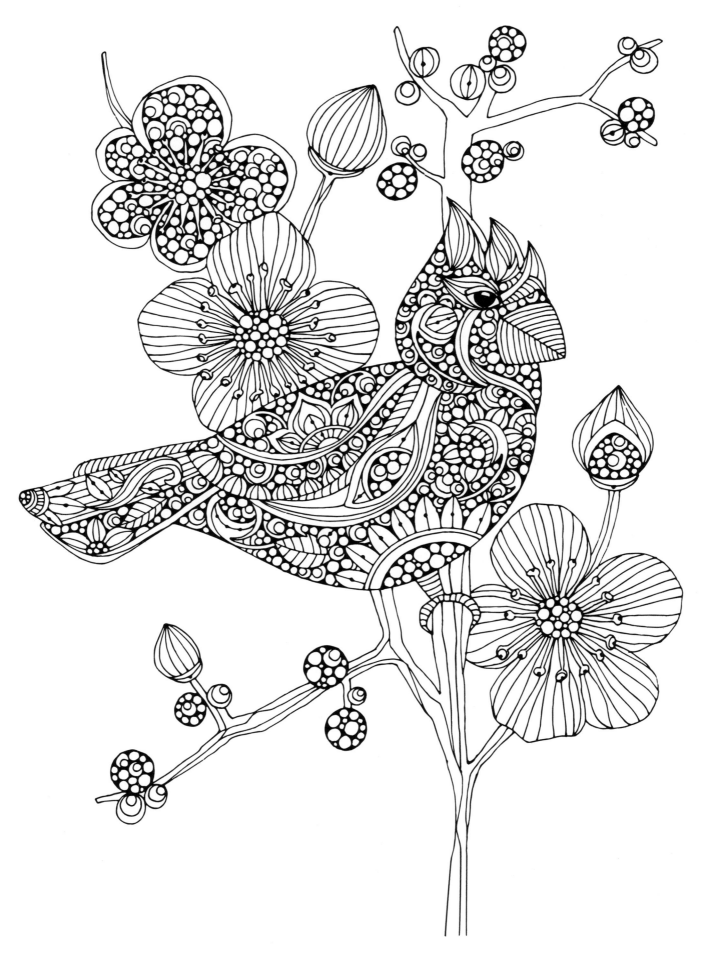

In the midst of our lives, we must find the magic that makes our souls soar.

—Unknown

Ernest

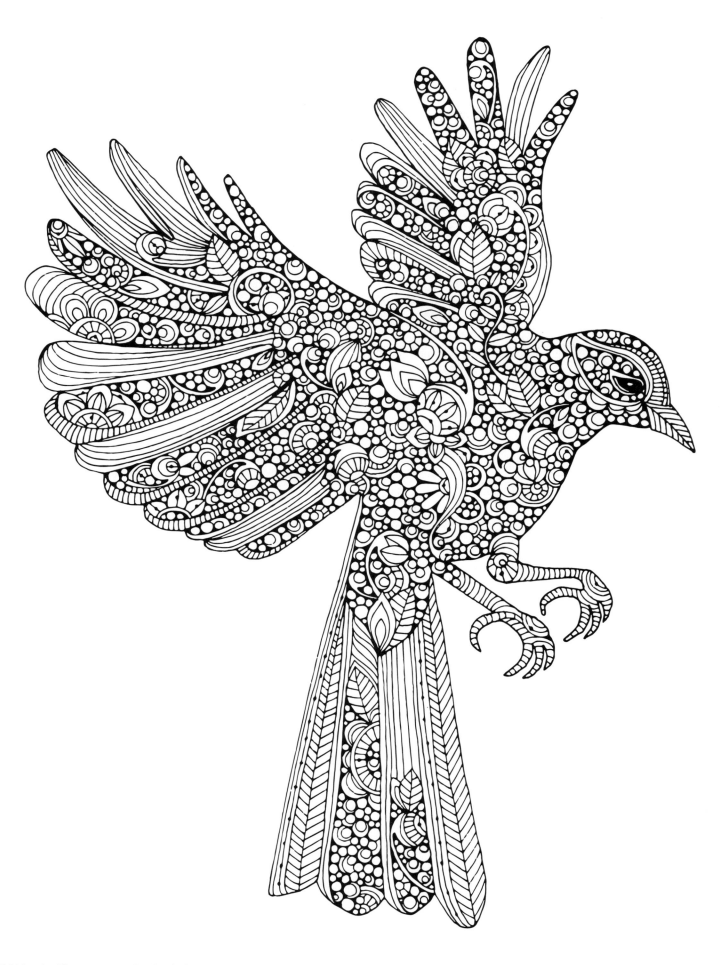

No bird soars too high, if he soars with
his own wings.

—William Blake

Florence

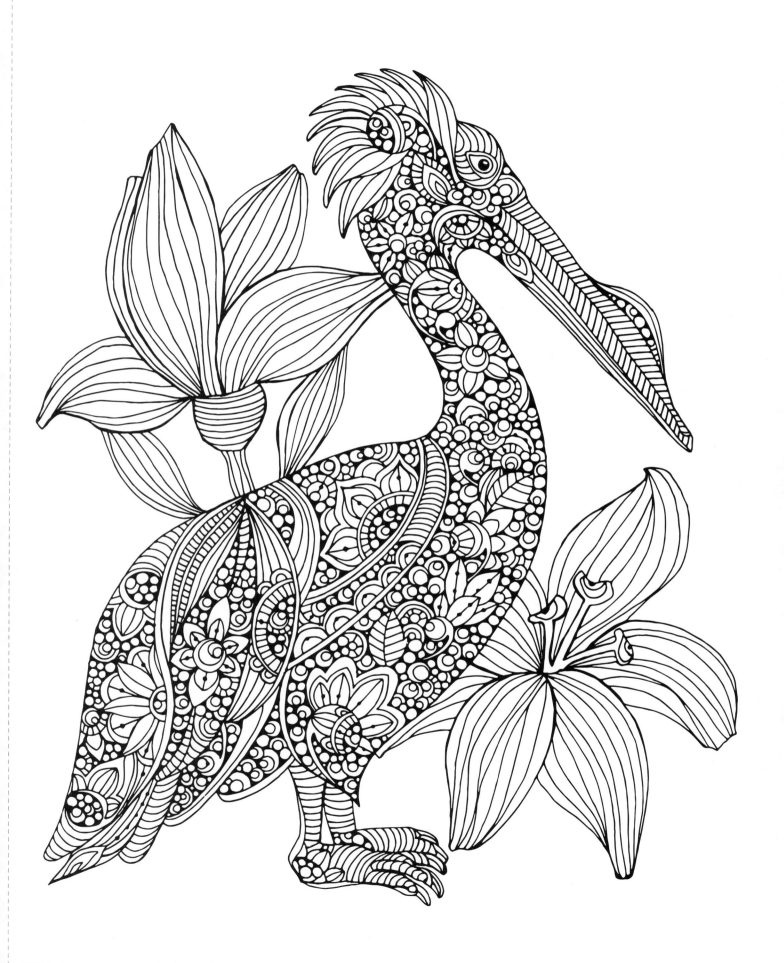

I decided to fly through the air and live in the sunlight and enjoy life as much as I could.

—Evel Knievel

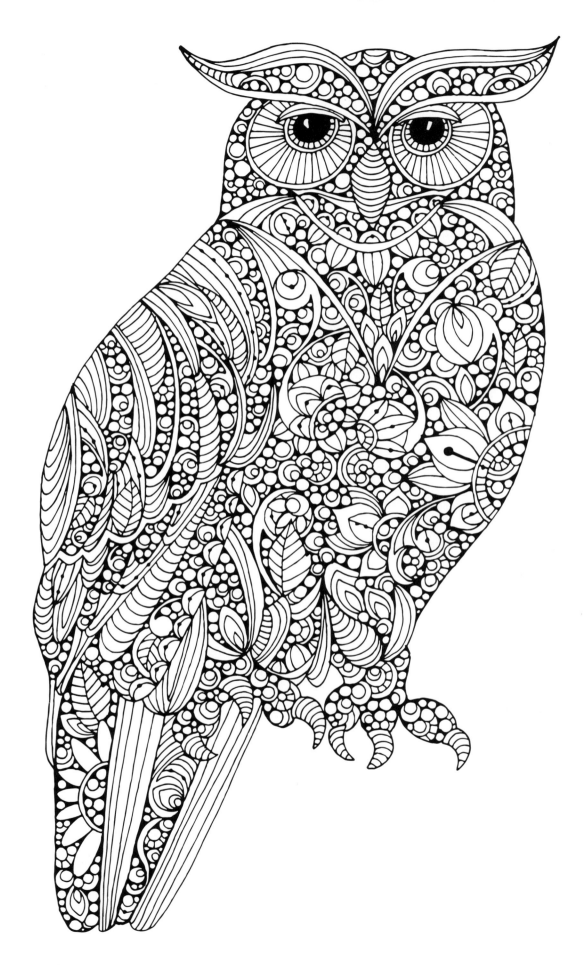

© Valentina Harper, www.valentinadesign.com

There is freedom waiting for you,
On the breezes of the sky,
And you ask "What if I fall?"
Oh but my darling,
What if you fly?

—Erin Hanson

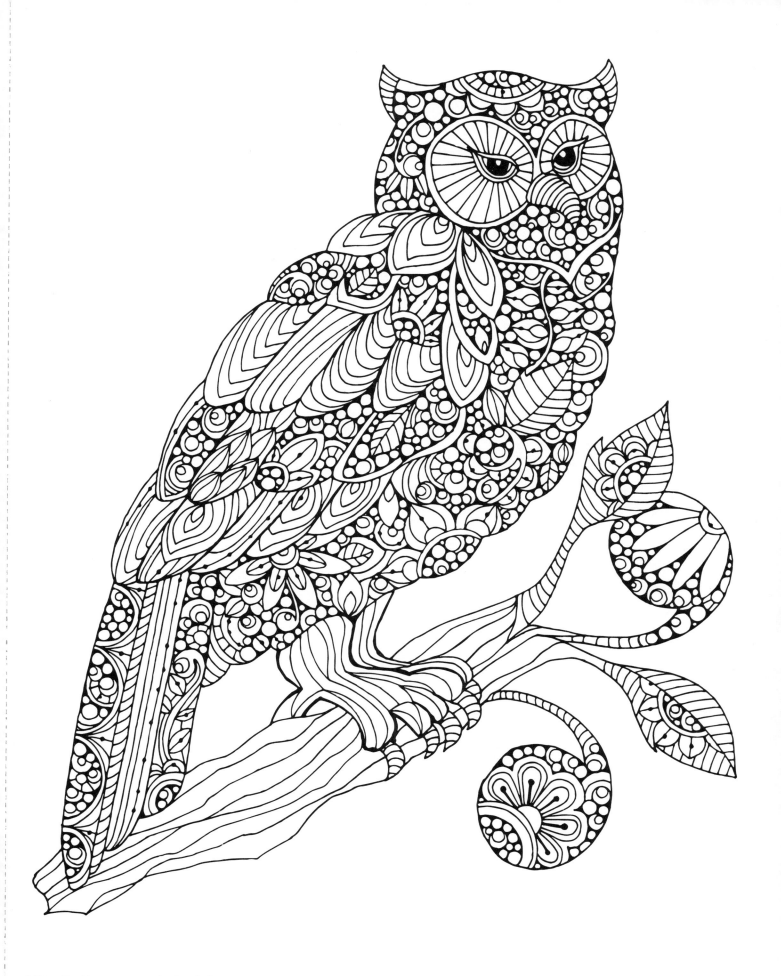

I always wonder why birds stay in the same place when they can fly anywhere on the earth. Then I ask myself the same question.

—Harun Yahya

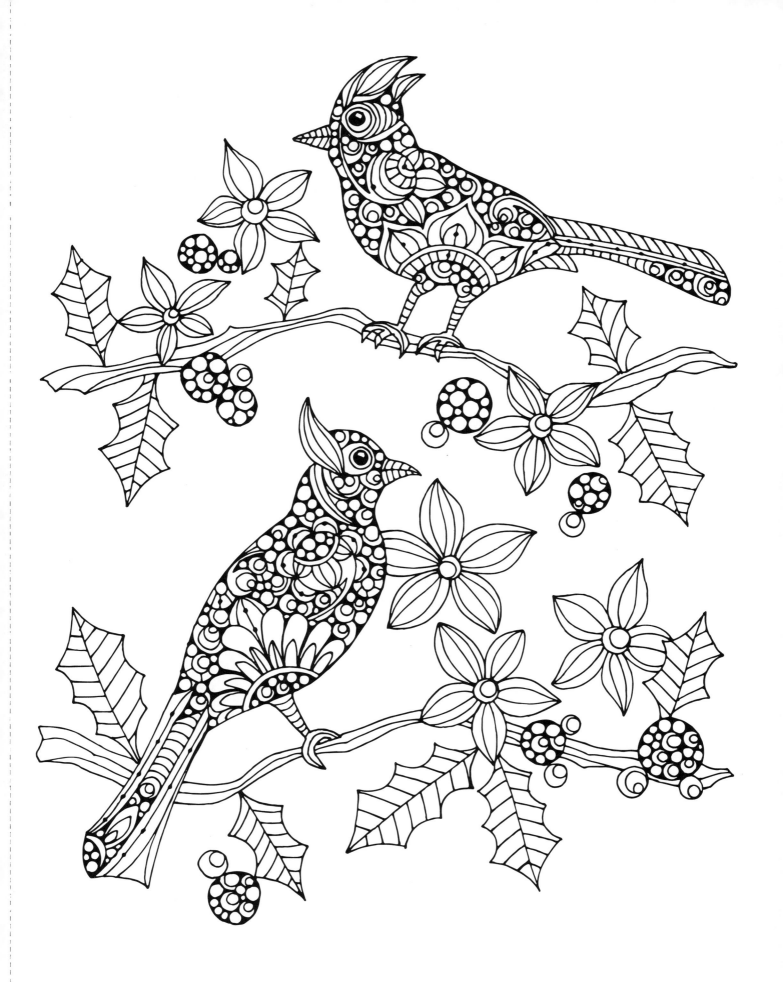

Long you live and high you fly
And smiles you'll give and tears you'll cry
And all you touch and all you see
Is all your life will ever be

—Pink Floyd, *Breathe*

Holly and Minnie

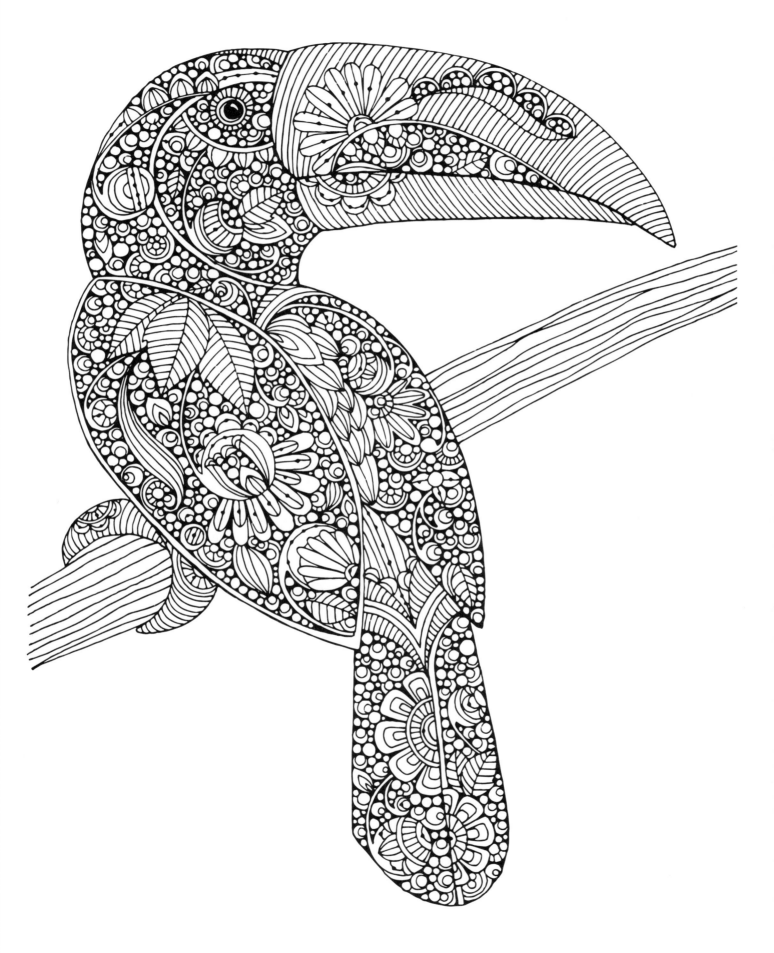

Refuse to be average. Let your heart soar
as high as it will.

—A.W. Tozer

Jacky

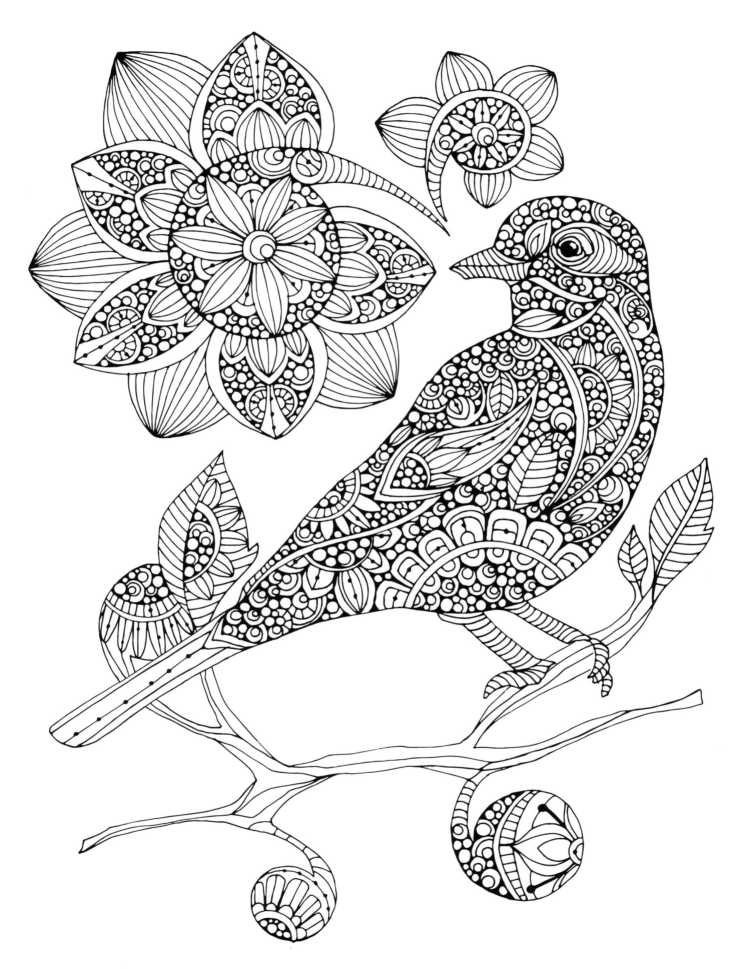

You have escaped the cage.
Your wings are stretched out.
Now fly.

—Rumi

Jonah

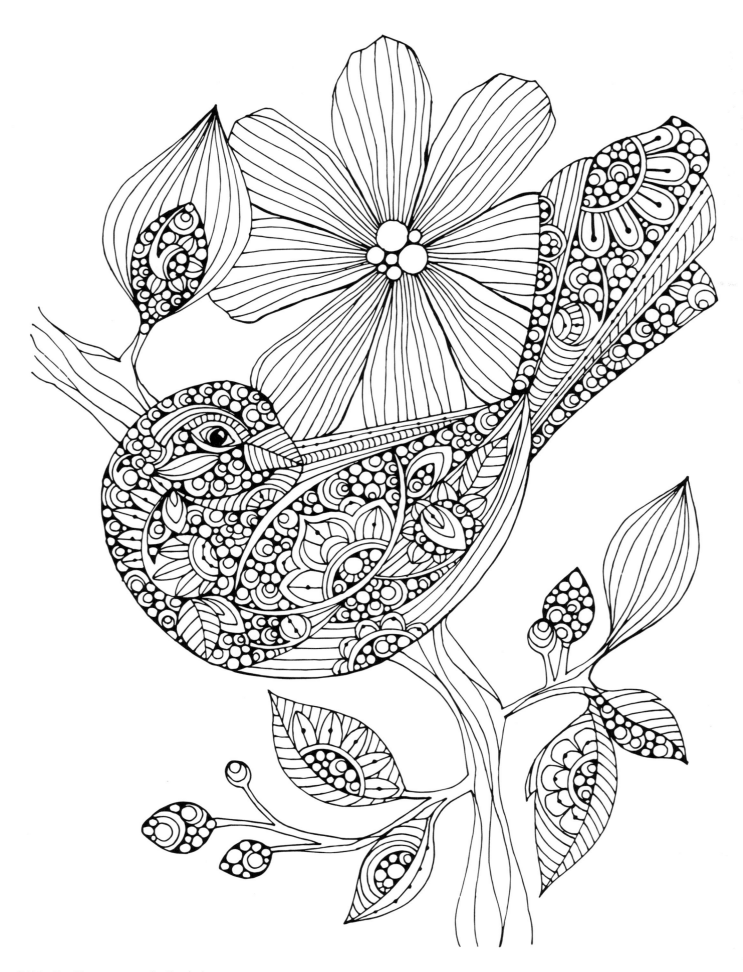

Beautiful things don't just happen. If you want something marvelous you've got to make something marvelous.

—Unknown

Juanita

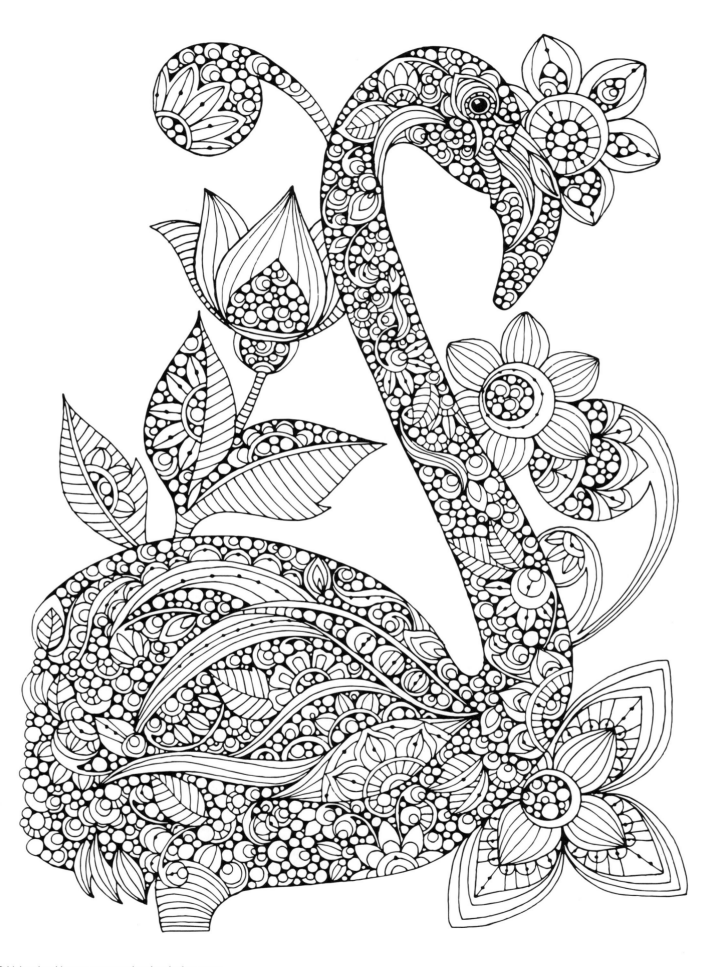

Be a flamingo in a flock of pigeons.

—*Confessions of a Teenage Drama Queen*

Lakshmi

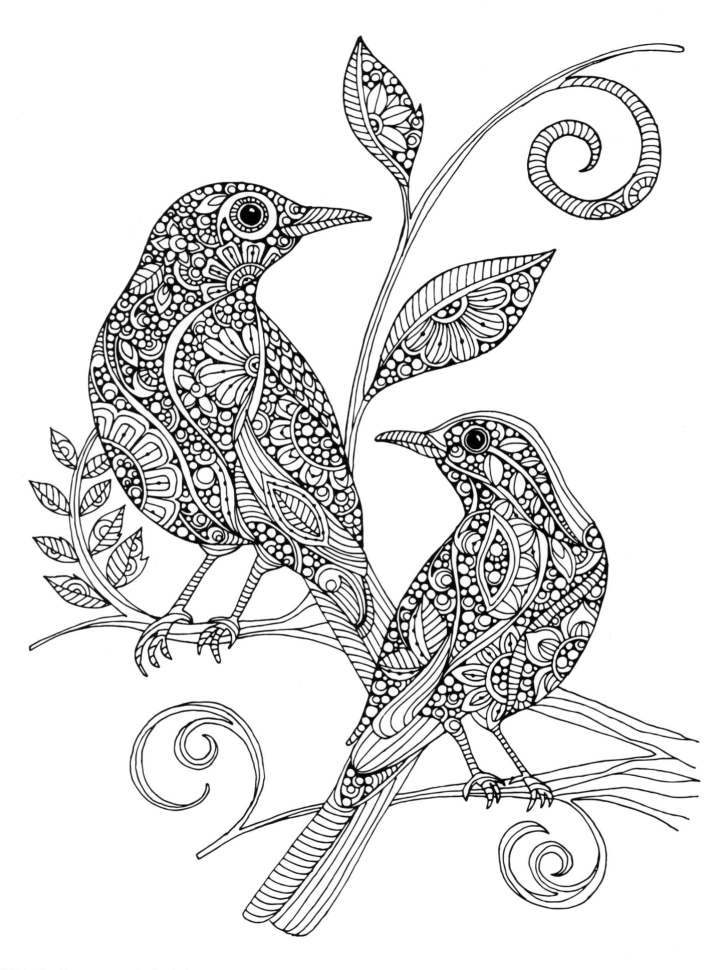

A friend is someone who knows the song in your heart, and can sing it back to you when you have forgotten the words.

—Unknown

Levy and Deborah·

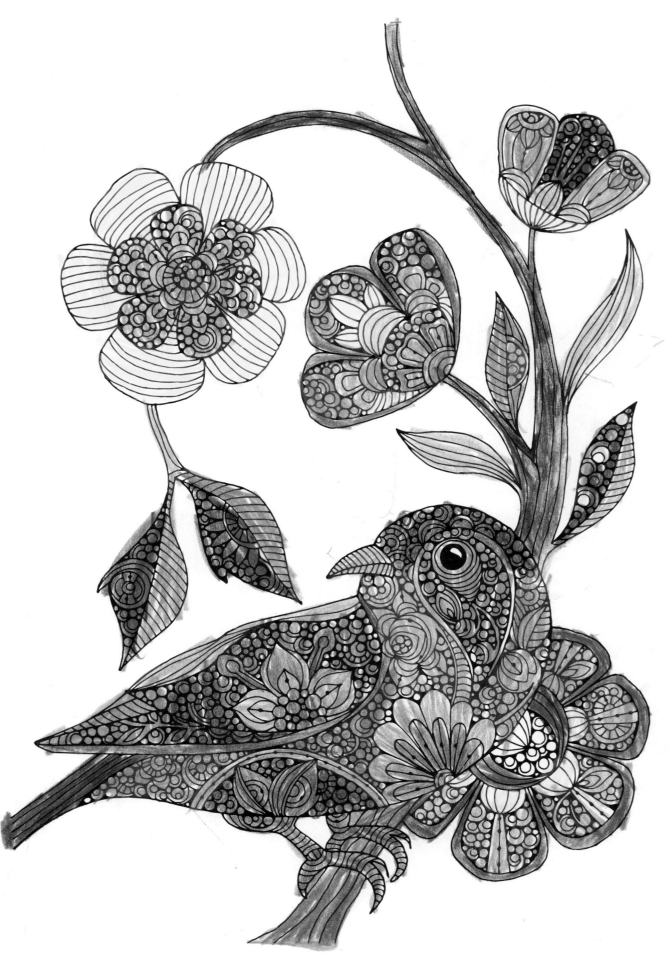

Don't tell me the sky's the limit
There's footprints on the moon

—Paul Brandt, *There's A World Out There*

Lianne

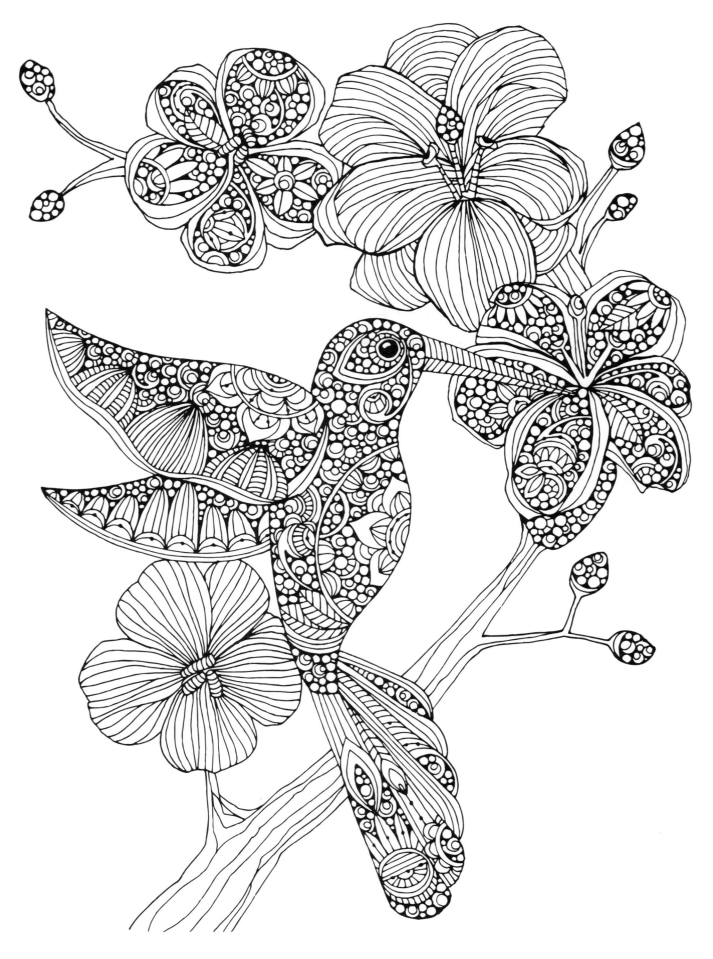

Anything's possible if you've
got enough nerve.

—J.K. Rowling

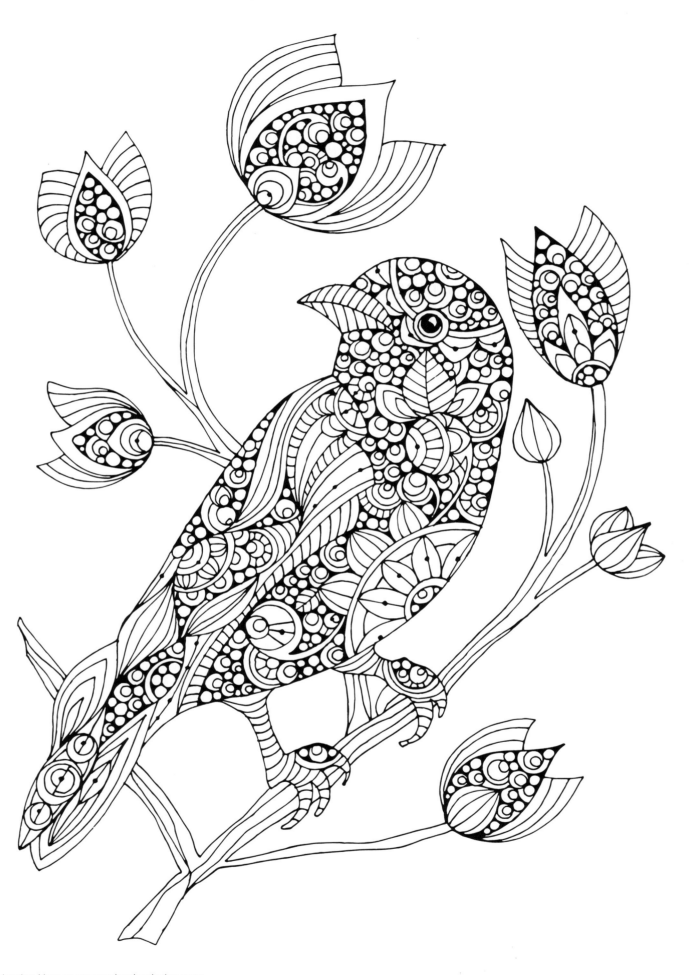

Hold fast to dreams
For if dreams die
Life is a broken-winged bird
That cannot fly.

—**Langston Hughes**, *Dreams*

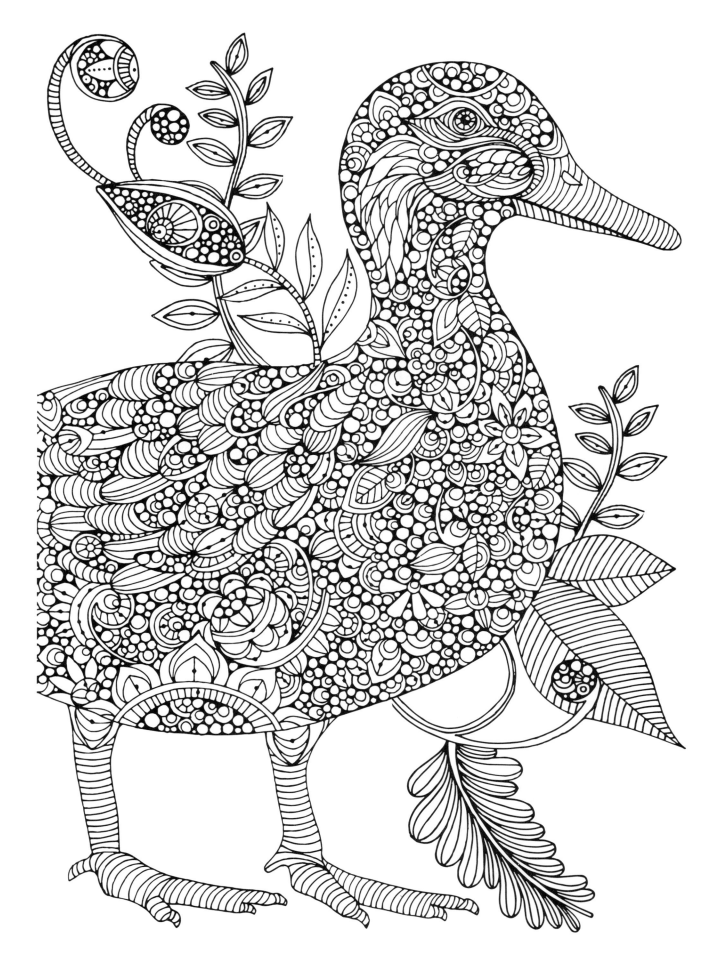

I want to sing like the birds sing, not worrying about who hears or what they think.

—Rumi

Molly

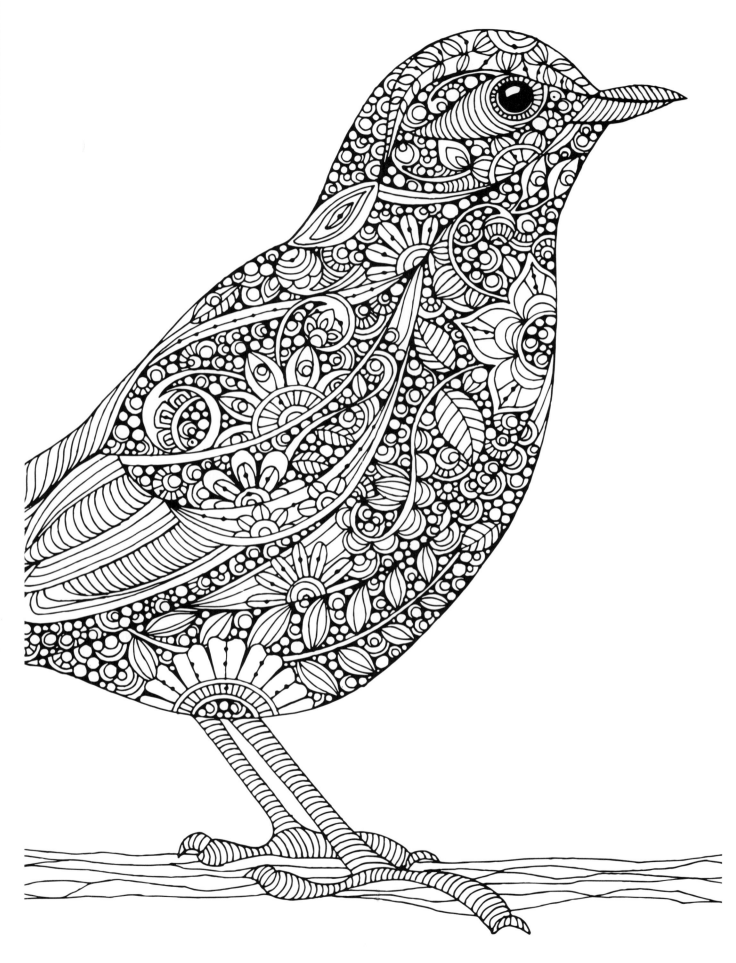

The earth has music for those who listen.

—George Santayana

Nancy

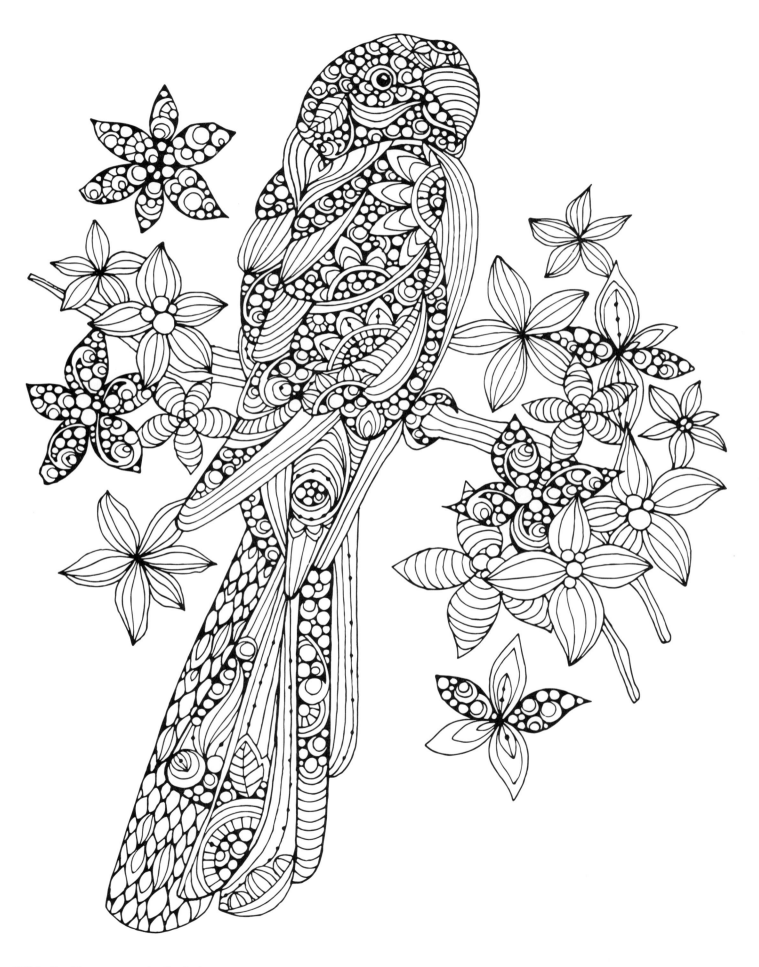

A bird sitting on a tree is never afraid of the
branch breaking, because her trust is not on
the branch but in her own wings.
Always believe in yourself.

—Unknown

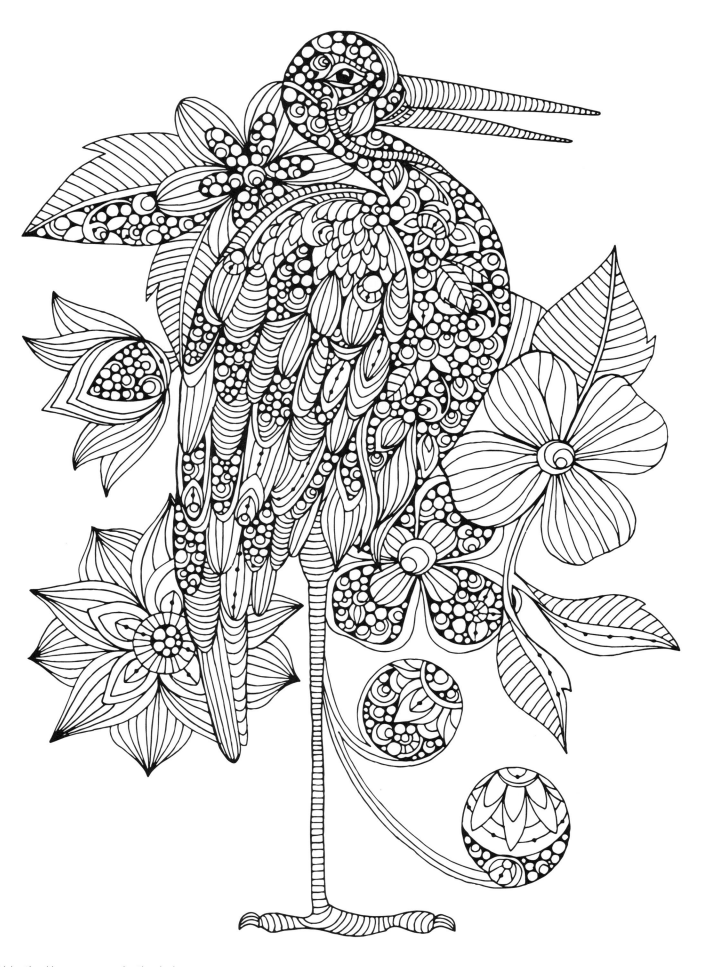

Today, I will be happier than a bird
with a french fry.

—Toni Nelson, *A Beggars Purse*

Olga

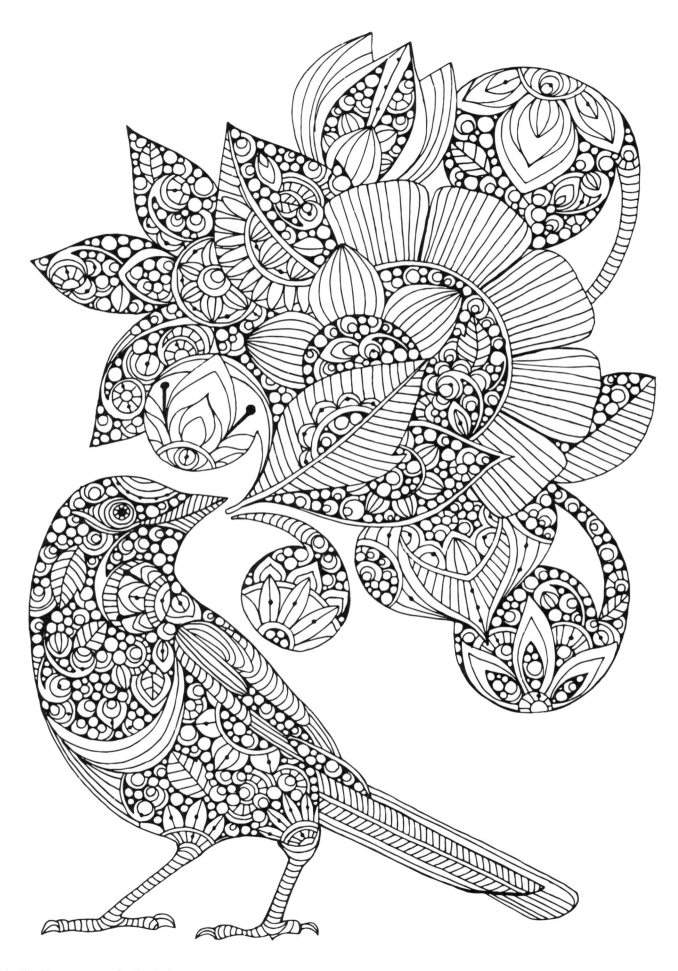

Keep a green tree in your heart and perhaps
a singing bird will come.

—Chinese proverb

Penny

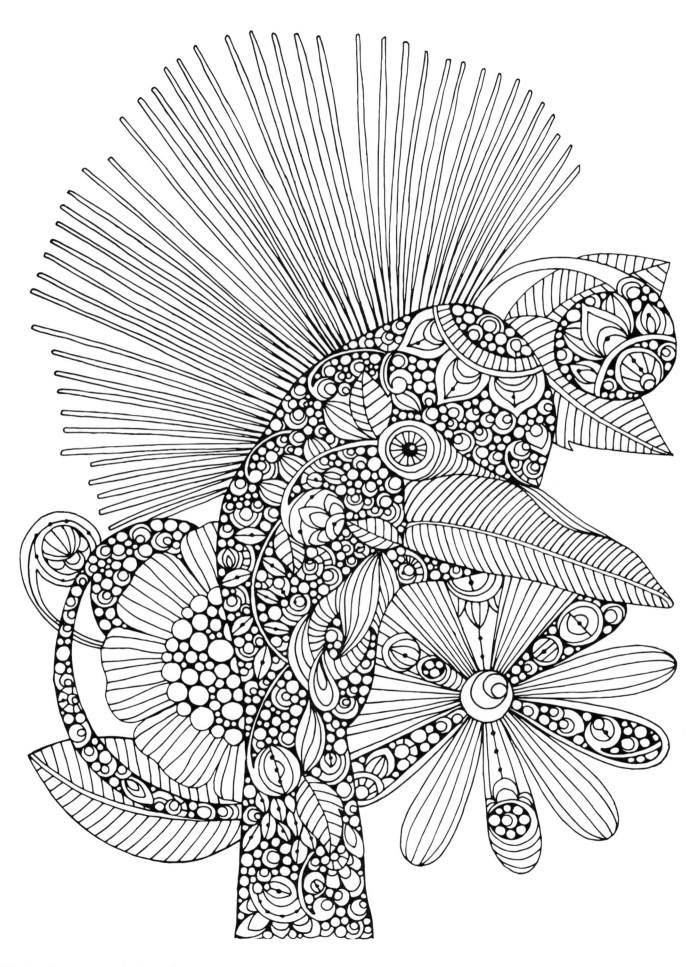

Smell the sea and feel the sky, let your soul
and spirit fly into the mystic.

—Van Morrison

Rachel

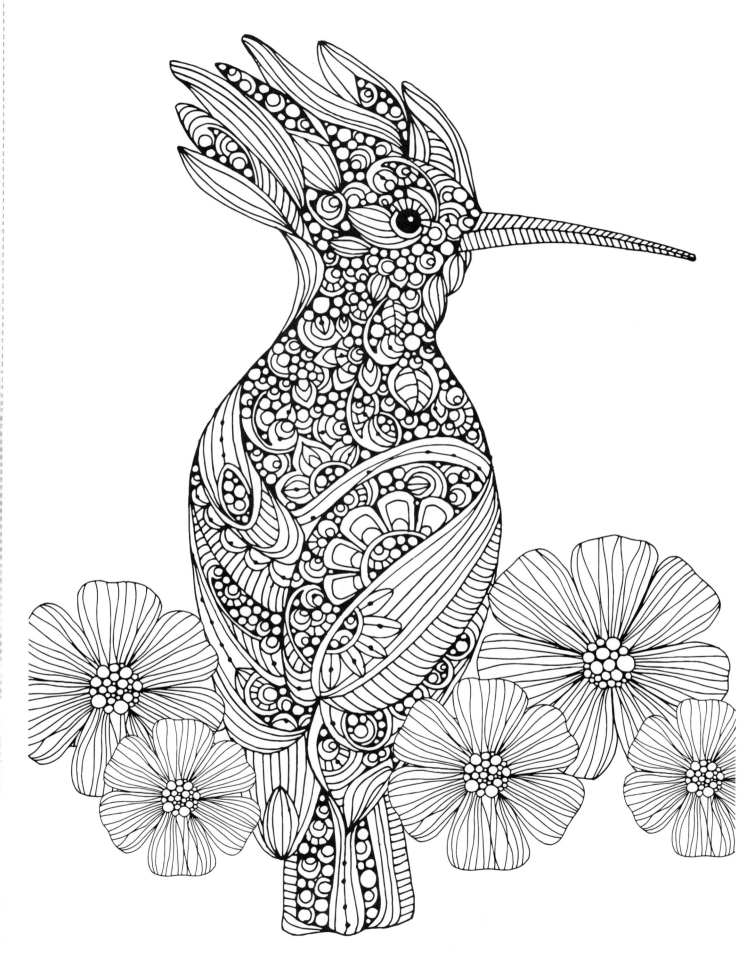

Come fly with me, let's fly, let's fly away.

—Frank Sinatra, *Come Fly With Me*

Rusty

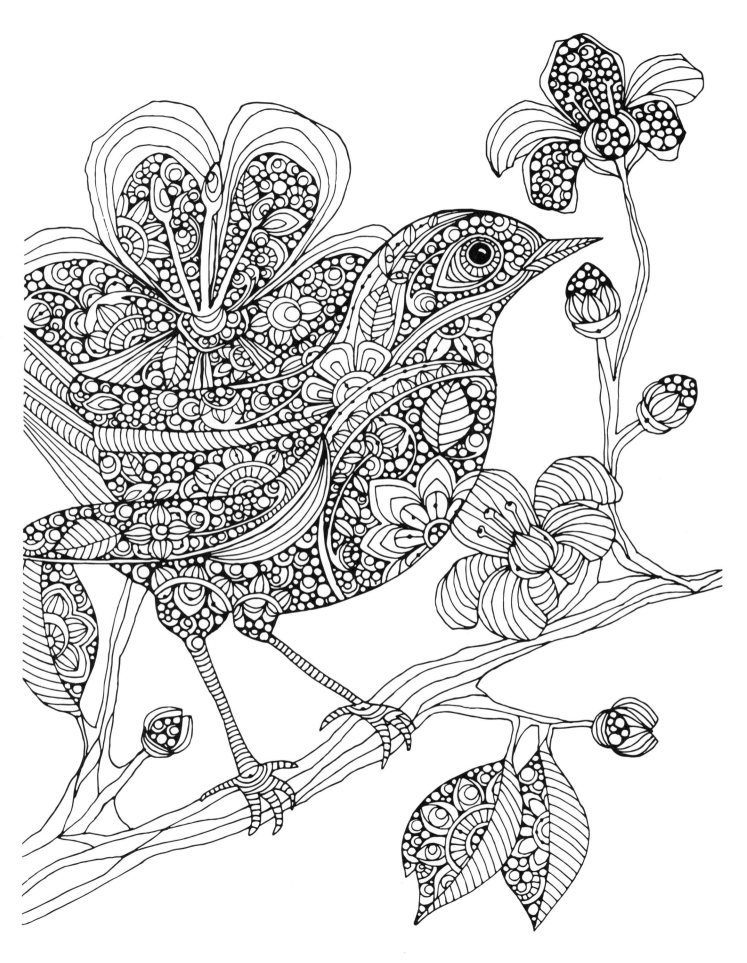

If you surrender to the wind, you can ride it.

—Toni Morrison

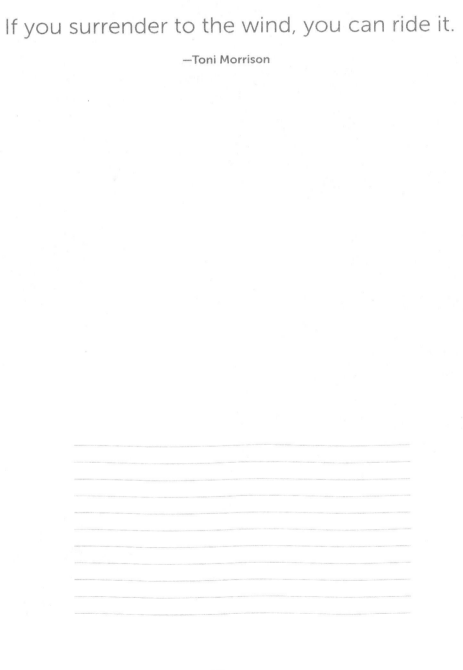

Sissy

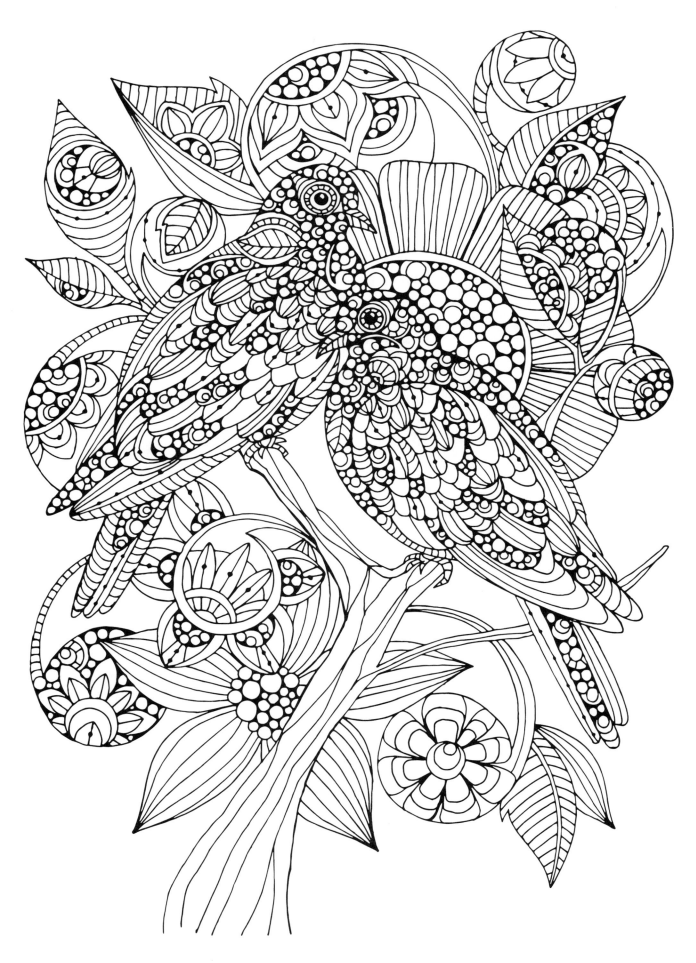

When you realize how perfect everything is,
you will tilt your head back and
laugh at the sky.

—Unknown

Sunny and Tony

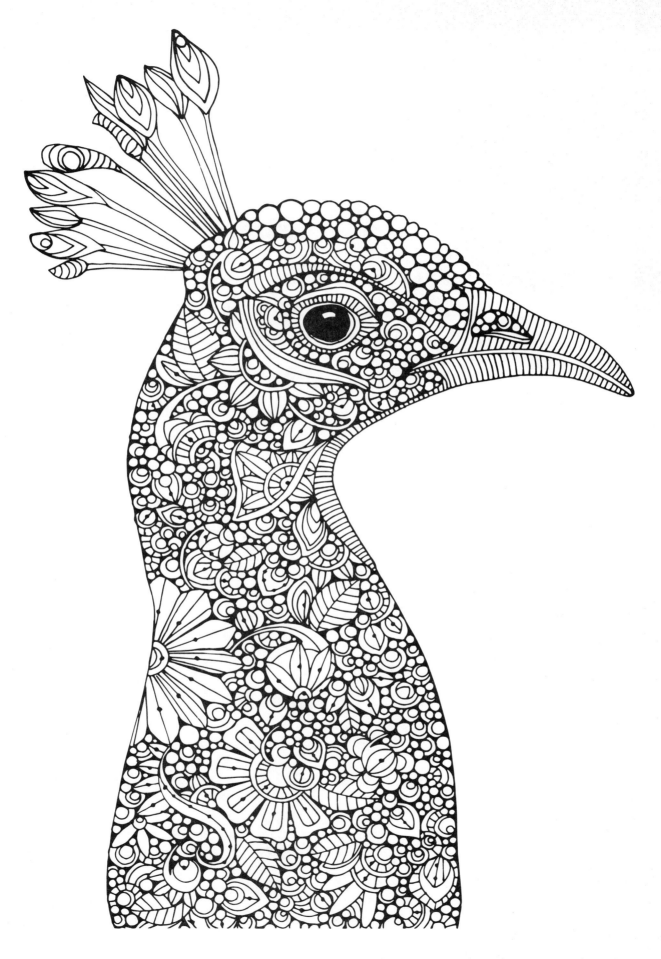

Some birds are not meant to be caged, that's all. Their feathers are too bright, their songs too sweet and wild.

—Stephen King, *Rita Hayworth and Shawshank Redemption*

Tom

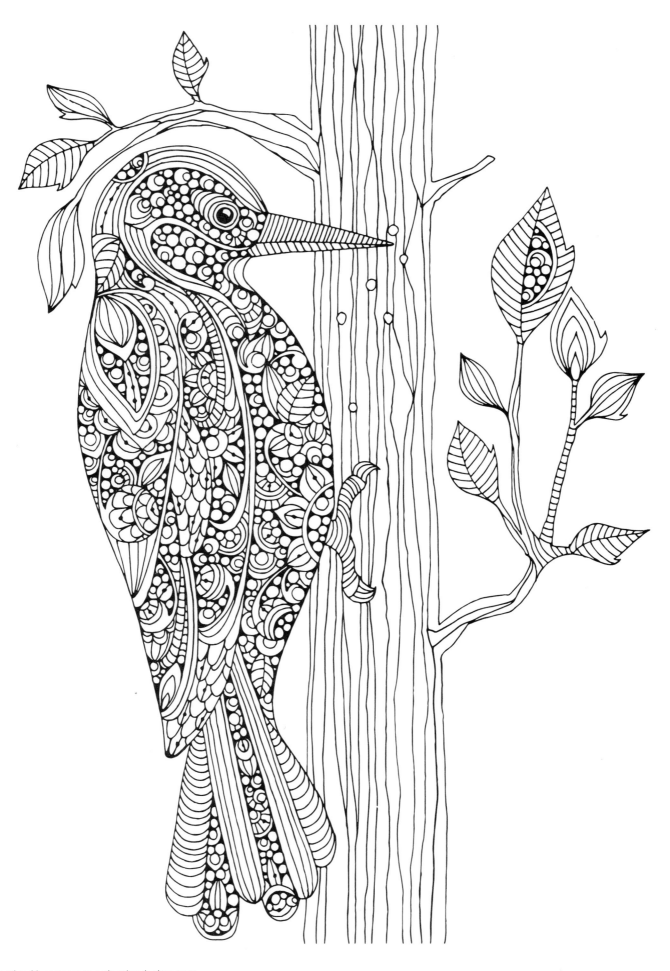

Don't worry about a thing,
'cause every little thing gonna be alright.

—**Bob Marley**, *Three Little Birds*

Wilbur